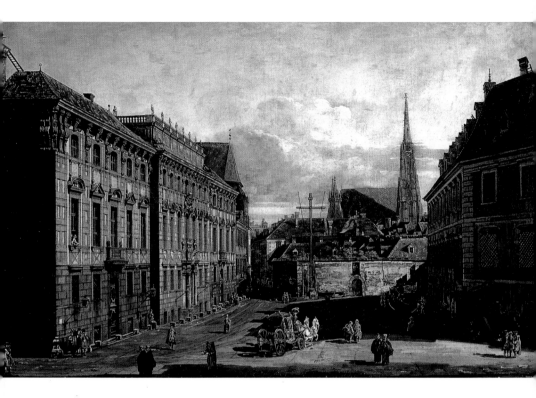

The Lobkowicz Collections

SCALA

The Lobkowicz
Collections in
association with
Scala Publishers

maciams laudibus im

ut discussis tenebris vic

ambulare niceamur uli

eum. In. Dum q̃ set nos

panum: psalterium

dum vm cythara

te in neomeniq tuba: in

die solennitatis ure

praeptum misit ē: xud

Contents

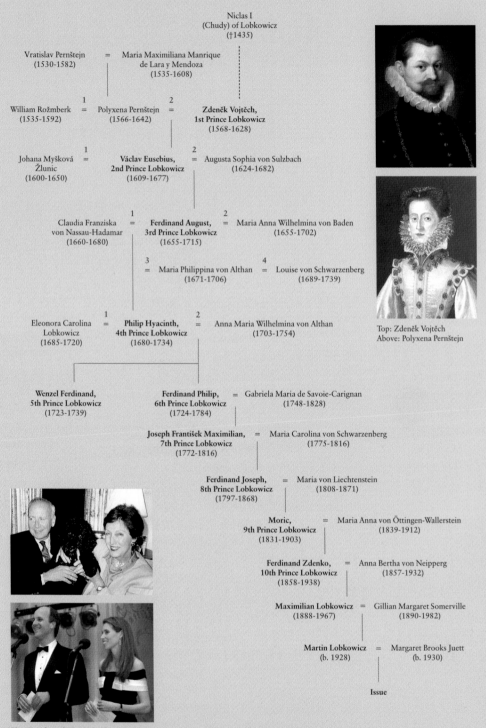

Niclas I
(Chudy) of Lobkowicz
(†1435)

Vratislav Pernštejn = Maria Maximiliana Manrique
(1530-1582) de Lara y Mendoza
(1535-1608)

1
William Rožmberk = Polyxena Pernštejn = **Zdeněk Vojtěch,**
(1535-1592) (1566-1642) **1st Prince Lobkowicz**
(1568-1628)

1
Johana Myšková = **Václav Eusebius,** = Augusta Sophia von Sulzbach
Žlunic **2nd Prince Lobkowicz** (1624-1682)
(1600-1650) **(1609-1677)**

1
Claudia Franziska = **Ferdinand August,** = Maria Anna Wilhelmina von Baden
von Nassau-Hadamar **3rd Prince Lobkowicz** (1655-1702)
(1660-1680) **(1655-1715)**

3 **4**
= Maria Philippina von Althan = Louise von Schwarzenberg
(1671-1706) (1689-1739)

1
Eleonora Carolina = **Philip Hyacinth,** = Anna Maria Wilhelmina von Althan
Lobkowicz **4th Prince Lobkowicz** (1703-1754)
(1685-1720) **(1680-1734)**

Wenzel Ferdinand, **Ferdinand Philip,** = Gabriela Maria de Savoie-Carignan
5th Prince Lobkowicz **6th Prince Lobkowicz** (1748-1828)
(1723-1739) **(1724-1784)**

Joseph František Maximilian, = Maria Carolina von Schwarzenberg
7th Prince Lobkowicz (1775-1816)
(1772-1816)

Ferdinand Joseph, = Maria von Liechtenstein
8th Prince Lobkowicz (1808-1871)
(1797-1868)

Moric, = Maria Anna von Öttingen-Wallerstein
9th Prince Lobkowicz (1839-1912)
(1831-1903)

Ferdinand Zdenko, = Anna Bertha von Neipperg
10th Prince Lobkowicz (1857-1932)
(1858-1938)

Maximilian Lobkowicz = Gillian Margaret Somerville
(1888-1967) (1890-1982)

Martin Lobkowicz = Margaret Brooks Juett
(b. 1928) (b. 1930)

Issue

Top: Zdeněk Vojtěch
Above: Polyxena Pernštejn

Top: Brooks and Martin Lobkowicz
Above: Alexandra and William Lobkowicz

Introduction

I T'S BEEN ONE HUNDRED YEARS since the Czech art historian Max Dvořák published the first comprehensive study of the Lobkowicz family collections in 1907. Needless to say, the century that has elapsed since then has been an enormously eventful one. Like the people around them, the Collections rode out a world war, the creation of an independent republic, a second world war, the Communist takeover, 40 years behind the Iron Curtain and, finally, the liberation of the Velvet Revolution in 1989. Nor did they do so without casualties; for 50 years, our paintings, books, musical scores and decorative arts were dispersed and, in some cases, lost – equally attractive to the Nazi regime, which sought to incorporate the best pieces into Hitler's Reichsmuseum, as to the apparatchiks who appropriated them a decade later.

Then, in 1991, President Václav Havel signed three acts providing for the return of confiscated property. With the help of extensive documentation like Dvořák's, we were able to trace and reclaim most of the treasures that had been taken from the family. It's been an exhausting enterprise, and one whose many challenges show no sign of relenting. Today, though, we are proud to have reunited most of the Lobkowicz Collections at both Nelahozeves Castle – which we first opened to the public in 1997, and where the permanent exhibition "Private Spaces: A Noble Family at Home" has been on view since 2007 – and at the Lobkowicz Palace in Prague, where "The Princely Collections" opened earlier that same year.

The work involved in creating these exhibitions has been made possible through our Czech non-profit organization – The Lobkowicz Collections, o.p.s. – as well as through contributions from a foundation in the United States – the American Friends for the Preservation of Czech Culture. The support provided by these two groups and by all of our sponsors and supporters is critical as we continue to expand and refine the exhibitions, working to make every part of the Collections available to visiting scholars, as well as to establish educational programs and special exhibitions in the future.

We hope the pages that follow will give you a sense of the treasures displayed in both exhibitions, and that you will share this guide with others as well, encouraging them to visit us here. On behalf of our family, we look forward to welcoming you to both the Lobkowicz Palace in Prague and out at Nelahozeves Castle.

ALEXANDRA AND WILLIAM LOBKOWICZ

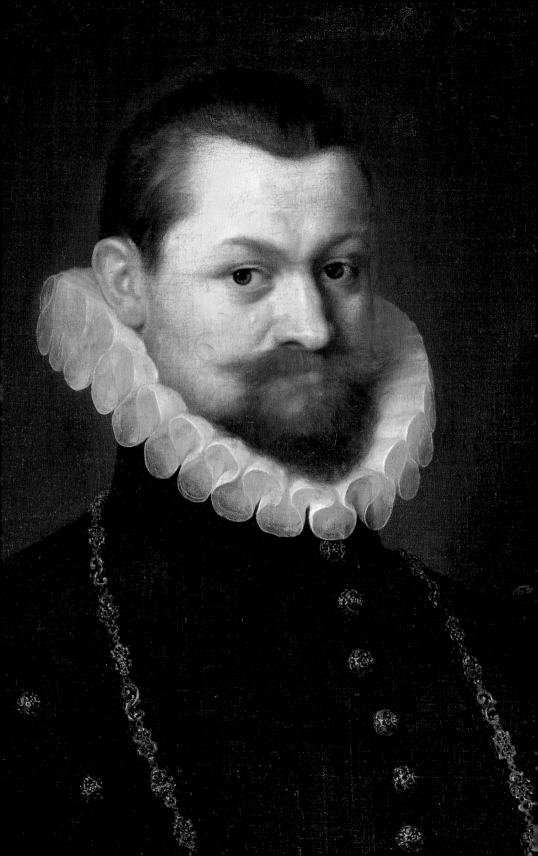

Family History

To walk through the halls of the Lobkowicz princes, to enter their galleries and rooms, was to become acquainted – sometimes subtly, sometimes directly – with their power and patronage. On a scale of few other families in Central Europe, the Lobkowiczes identified themselves through the architecture, paintings, books, music and decorative arts they commissioned. And while various generations of Lobkowiczes would respond to their respective political situations in quite different ways, the family consistently used their possessions to project an image of strength, from their ennoblement in the fifteenth century, and the peak of their influence two centuries later, to the seemingly irreversible losses of the twentieth century.

Prague in the 1530s, during the rule of the newly crowned King of Bohemia, Ferdinand I, underwent a transformation that by the turn of the century would make it one of the most dynamic political, intellectual and cultural centers in Europe. Ferdinand's son, the Holy Roman Emperor Maximilian II, continued to frequent the city, but it was Maximilian's son, Rudolf II, who in 1583 officially moved the Imperial court from Vienna to Prague, partly in response to the growing Turkish threat to the south. Such attention drew waves of politicians and diplomats, architects, scientists and doctors. It also made the city a magnet for painters, sculptors, printers, publishers and artisans of all kinds. The result was a staggering Imperial collection, housed in the Prague Castle, which, by the time of Rudolf's death in 1612, was the admiration and envy of every European ruler.

Small wonder, then, that the most powerful families of Bohemia and Moravia, who owed their wealth to enormous land-holdings, came to Prague to compete for attention and influence. While these

Emperor Rudolf II (detail), studio of Alonso Sánchez Coello, oil on canvas, *c.*1570

Zdeněk Vojtěch,
1st Prince Lobkowicz,
Bartholomeus Spranger,
oil on canvas, *c.*1600

aristocrats may have sought to enter the Emperor's orbit, however, not all of them shared his political views. Throughout Europe, the Catholic Church had intensified its resistance to a growing Protestant influence, and in Prague there was increasing friction between the independent-minded, largely Protestant nobility and the Catholic inner circles of the Habsburg court – in which the Lobkowiczes, as Chamberlains and Chancellors, were playing an expanding role.

Indeed, when this political stalemate led to the revolt of the Protestant Bohemian Estates in 1618, the Lobkowiczes found themselves at the center of the conflict. At a meeting with representatives of the Estates, two of the Emperor's ministers were hurled from a window of the Prague Castle, ending dialogue between the two groups. Surviving the fall, they took refuge in the adjacent Lobkowicz Palace. That moment is commemorated in a painting depicting Polyxena, Princess Lobkowicz (1566–1642), as she shields the bloodied and bandaged men behind her, refusing admission to a crowd of Protestants who have broken in to dispense with the men. This is a romantic, latter-day recreation of the scene, of course, but it serves to illustrate a critical juncture in the fortunes of the Lobkowicz family.

Polyxena and her husband Zdeněk Vojtěch, 1st Prince Lobkowicz (1568–1628) were leaders of the Catholic, or "Spanish," faction opposing the local Protestants. As Chancellor of the Czech Kingdom (under Emperors Rudolf II, Matthias and Ferdinand II) Zdeněk Vojtěch was the ruler's right-hand man. Polyxena was connected to powerful families throughout Europe and was noted for her political and diplomatic skills. She was the daughter of Vratislav Pernštejn, a Chancellor of the Czech Kingdom, and Maria Manrique de Lara y Mendoza, whose family was active at the court of Philip II of Spain. Polyxena's first husband, William Rožmberk, once the richest aristocrat in the land, had played a major role in foreign policy as Supreme Burgrave. Such family connections tied the Lobkowiczes particularly closely to the Spanish diplomats and courtiers trying to protect Habsburg interests in Bohemia, resulting in a constant exchange of communication between Prague and Madrid, which was amply represented by religious and decorative paintings, objects and books commissioned from Spanish artists and brought to the Lobkowicz Palace in Prague.

Following the outbreak of hostilities in 1618, the Protestants confiscated all of Zdeněk Vojtěch's and Polyxena's property. It was a

Pernštejn (top) and Lobkowicz (below) coats of arms in *pietra dura* (detail from house altar, 1603), Giovanni (?) Castrucci, Prague

Polyxena Pernštejn, 1st Princess Lobkowicz, was connected to powerful families throughout Europe and was noted for her political and diplomatic skills. *Portrait believed to be of Polyxena Pernštejn* (detail), attributed to Roland de Mois, oil on canvas, *c.*1585

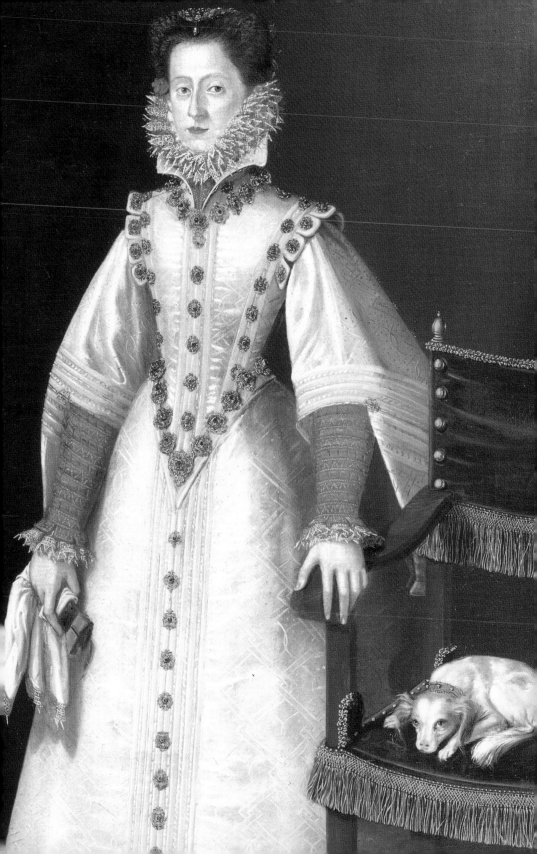

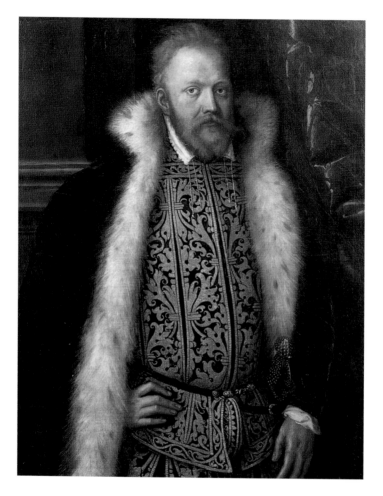

Vratislav Pernštejn,
Jacob Seisenegger,
oil on canvas, 1558

short-lived victory, however; in 1620 the Protestants suffered a decisive defeat at the Battle of White Mountain, on the outskirts of Prague. This was only the beginning of the Thirty Years' War, but for the Lobkowicz family it was a moment which would confer lasting benefits, enabling them to consolidate their influence and power base for the next three centuries. Although Polyxena was quick to make charitable contributions to some of the widows of the Protestant rebels executed in 1621, it was understood that she and her husband, who had worked so zealously for the Habsburg faction in Bohemia, would take their due from those vanquished – and the rewards were immediate. Certainly their collections were augmented at this point, most notably in the library, but it was the great confiscated land-holdings – now newly available and easy to acquire – which ensured that the family would play a dominant role in Bohemia for centuries

Doña Maria Maximiliana Manrique de Lara and child, Georges van der Straeten, oil on canvas, c.1575

to come. Nelahozeves Castle, bought by Polyxena from the family of Florian Griesbeck von Griesbach in 1623, was just one of these opportunities.

Václav Eusebius, 2nd Prince Lobkowicz (1609–77), was the only child of Polyxena and Zdeněk Vojtěch. Like his parents, he was intensely involved in politics and well-positioned to take advantage of Catholic dominance throughout Central Europe. Václav Eusebius first made his mark on the battlefields of the Thirty Years' War, having raised his own regiment to fight in 1632. He subsequently became a counselor at the court in Vienna, advising both Ferdinand III and Leopold I. And as President of the Imperial War Cabinet after 1652, and President of the Imperial Privy Counsel from 1669, he was one of the most influential European statesmen of the seventeenth century.

Well aware that buildings could be exploited as symbols of power,

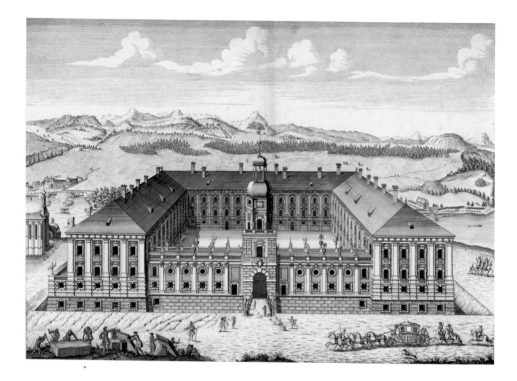

Václav Eusebius was as interested in architecture as he was in politics. After falling from the Emperor's favor in 1674, it is said he had a special room constructed at Roudnice Castle (the family's principal seat) to remind him of the vicissitudes of fortune: one half a splendid salon, the other a peasant's hovel. His most lasting contributions, however, were the family palaces he had reconstructed by Italian architects and stuccoists in the Baroque style that had just begun to sweep across Central Europe. The Lobkowicz Palace, which, along with Prague Castle, still dominates the city's skyline, was the most visible of these projects. Then, in 1653, Francesco Caratti began work on Roudnice, transforming it from the ruin Václav Eusebius had inherited from his mother into one of the most impressive residences in Bohemia. It would serve as the family seat until 1948. Caratti worked for Václav Eusebius until 1665, subsequently leaving to help design the Czernin Palace in Prague, where he remained until his death in 1677. Carlo Orsolini continued the work on Roudnice, but it was Antonio della Porta who gave the building its final shape, working for the family until 1697. In 1646 Václav Eusebius had purchased the ducal estate of Sagan in Silesia from Emperor Ferdinand III. Previously in the possession of General Albrecht Wallenstein, this was among the

Roudnice Castle seen from the south, Jeremias Wolff, copperplate engraving, Augsburg, 1715

Roudnice became one of the most impressive residences in Bohemia, serving as the family seat until 1948

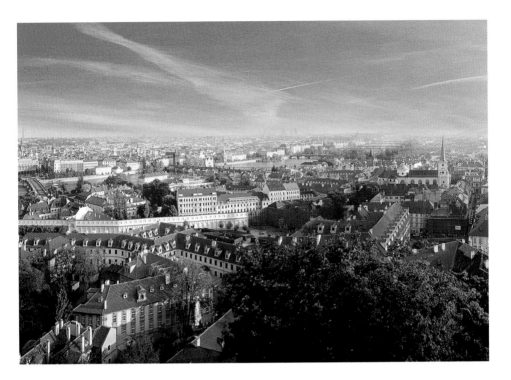

The view from **Lobkowicz Palace** over Prague looking south

most valuable prizes of the Thirty Years' War, and Václav Eusebius set della Porta to work to enhance the glory of the castle by rebuilding it from the ground up.

Indeed, Sagan was so valuable a holding as to confuse the allegiances that had helped procure it. Václav Eusebius's great-grandson, Ferdinand Philip, 6th Prince Lobkowicz (1724–84), was 16 years old when Frederick the Great of Prussia invaded the Habsburg province of Silesia in 1740, triggering the War of the Austrian Succession. Rather than risk confiscation of his immense and profitable Silesian estate, Ferdinand Philip tacitly supported Frederick over the Habsburg Empress, Maria Theresa. It was an unprecedented step for a family that had long provided staunch support to the Holy Roman Empire. Nor was it any accident that Ferdinand Philip would be one of only two reigning Lobkowicz princes not to be received into the Order of the Golden Fleece, the highest European order of chivalry.

During the war, and the unsettled years that followed, it was essential that Ferdinand Philip remain absent not only from Bohemia but also from Vienna – where he probably would not have been welcome – and also from his Sagan estate, which was too close to the lines of battle. With his relationship to the Habsburgs compromised,

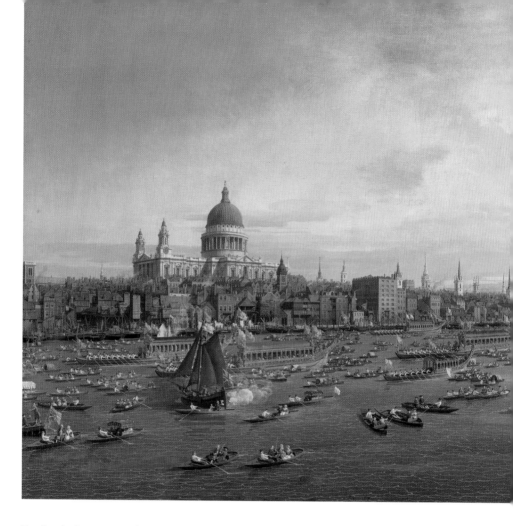

England, far removed from the conflicts of Central Europe and friendly to Prussian interests, would have seemed an ideal destination for the young prince. His stay there also provided him with an unusual opportunity to enhance his art collections back home. By the time Ferdinand Philip returned to Bohemia, he had acquired two of Canaletto's finest English views, both of London, executed in the late 1740s.

These paintings and the actions that led to their acquisition reflected a changing Europe: the rise of Georgian England and Hohenzollern Prussia, even as the influence of the Habsburgs was waning. Ferdinand Philip's choices reflected those of a princely house that had come to maturity. No longer was it necessary to court the Habsburgs at every step; indeed, in certain situations there was every advantage to be gained by not supporting them. Shortly after Ferdinand Philip's death, the estate he had so cannily protected was

London: The Thames on Lord Mayor's Day (detail), Antonio Canaletto, oil on canvas, c.1750

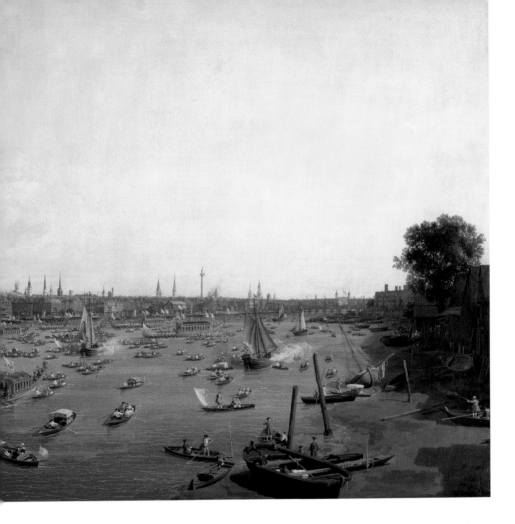

Ferdinand Philip's stay in England provided him with the opportunity to enhance his art collection

sold to the Duke of Courland for the then staggering sum of one million gulden. Once again, through prudent politics, the Lobkowicz fortunes had increased – as had the family collections.

Despite the perhaps understandable distance he maintained from Ferdinand Philip, the Emperor Joseph II established amicable relations with Ferdinand Philip's son, the 7th Prince Lobkowicz, Joseph František Maximilian (1772–1816), bestowing upon him the title of Duke of Roudnice in 1786. The Lobkowicz Palace in Vienna now became the center of the family's political and cultural activities. By the first third of the nineteenth century, the Lobkowiczes had risen to become one of the most prominent families not just of Bohemia but of the whole of Europe. Such status would remain undisturbed until the upheaval of the First World War and the subsequent disintegration of the Austro-Hungarian Empire.

František Drtikol's photograph of Maximilian Lobkowicz

(1888–1967), the last heir to occupy Roudnice, is deceptively simple. While none of the earlier, more obvious symbols of power are used to affirm the sitter's status here, neither does this portrait for a new age convey a sense of egalitarianism. Thus, it conveys the dual aspects of Max Lobkowicz's personality: both the progressive inclinations evident in the work he did on behalf of the First Czechoslovak Republic, as well as a keenly felt sense of his family's status.

Like many of his ancestors, Max Lobkowicz was a politician and a diplomat. Like them, he was forced to choose between opposing forces working within and outside of Bohemia. But whereas they tended to be involved in politics in order to increase or maintain the family's interests amid Bohemia's almost constant state of political uncertainty, the twentieth-century politics by which Max Lobkowicz defined himself took the family in utterly new directions. And if not, perhaps, acting against his own class, family and material interests, he certainly placed his loyalty to the state of Czechoslovakia first and foremost.

Many aristocratic families whose property fell within the new Czechoslovak state after 1918 chose to claim German or Austrian nationality. Later, in the 1930s, as tensions grew between Czechs and the large German-speaking minority in Bohemia, with the German Reich on the border growing increasingly threatening, an even greater strain was placed upon loyalties to the Czechoslovak government. It is against this backdrop that Max Lobkowicz's political views and actions may be fully appreciated for their independence. Despite the anti-aristocratic tendencies evident in the government's abolishment of hereditary titles and redistribution of certain land, he supported the young Republic at each of its most critical junctures. In the early days, he campaigned abroad for international recognition of the new Republic. Later, in the 1930s, he sought diplomatic support against German annexation of the Sudetenland. Then, during the Second World War, all of his holdings were confiscated because he represented the Czechoslovak government-in-exile in England. He continued as Ambassador to the Court of St. James even after the war, before the Communist putsch (precisely when he might have used his influence to move the family's priceless collections out of the country), choosing to demonstrate his confidence in Czechoslovakia's viability as a democracy.

It is, of course, rather ironic that this descendant of Zdeněk Vojtěch and Polyxena should sacrifice the Lobkowicz patrimony for convictions of Czech nationalism; if, during the sixteenth and seventeenth centuries the name Lobkowicz had meant Imperial

Today, the democratic transformation that Max Lobkowicz pursued remains an inspiring example

Max Lobkowicz (detail), František Drtikol, photograph, 1925

privilege, it now spoke of something entirely different – and undeniably Czech. Today, over half a century after the foundation of the Czechoslovak Socialist government that appropriated the Collections, and 18 years after the Velvet Revolution that restored them, the democratic transformation that Max Lobkowicz pursued remains an inspiring example. It is with this example in mind that the permanent exhibitions of restituted Lobkowicz treasures have been assembled at Nelahozeves Castle and the Prague Palace – buildings that changed hands several times for reasons of political advantage, but today stand open to all.

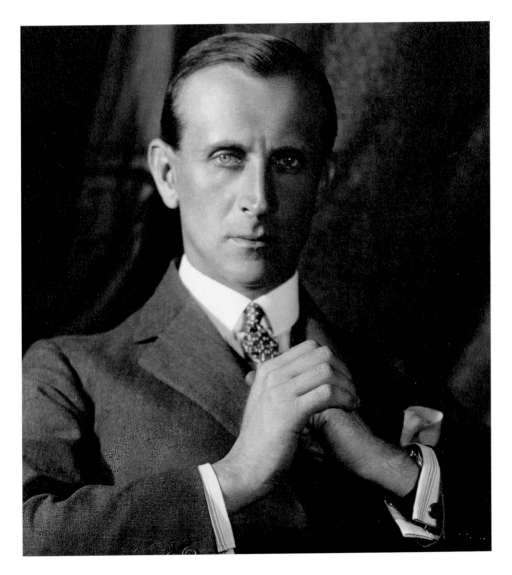

History of the Lobkowicz Palace

Prague Castle, home to the Lobkowicz Palace, is one of the most beautiful and significant cultural sites in Europe. Originally the Pernštejn Palace, the Lobkowicz Palace was built in the mid-sixteenth century by Czech nobleman Jaroslav of Pernštejn (1528–69). It was here that Maria Maximiliana Manrique de Lara, the Spanish-born wife of his brother Vratislav, Chancellor of the Czech Kingdom, brought the celebrated statue known as the Infant Jesus of Prague, renowned even today for its miraculous healing powers.

The building has borne its present name and has belonged to the Lobkowicz family since the marriage of Jaroslav's niece Polyxena (1566–1642) to the 1st Prince Lobkowicz (1568–1628) in 1603. In the centuries following that marriage, the Palace witnessed some of Bohemia's most significant historical events, including the famous "defenestration" of Prague in 1618, when Protestant rebels threw the Catholic Imperial ministers from the windows of Prague Castle.

As a result, the Palace underwent a number of changes. Despite this, however, all periods of its architectural history can still be seen today. Among those parts of the building that were altered, of particular note are the Chapel and the Palace's magnificent reception rooms, today known as the Concert Hall, the Balcony Room and the Marble Hall. These were improved and embellished in the mid-seventeenth century by the politically powerful 2nd Prince Lobkowicz, Václav Eusebius (1609–77). His four-times great-grandson, Joseph František Maximilian, 7th Prince Lobkowicz (1772–1816), best known as one of Beethoven's most generous benefactors, was responsible for the Palace's present-day exterior, a reconstruction he commissioned for Emperor Leopold II's 1791 coronation as King of Bohemia.

For 300 years, the Palace was passed down to each ruling Prince.

After the First World War, and following the abolishment of hereditary titles in 1918, Maximilian, son of the 10th Prince Lobkowicz, demonstrated his support for the new Republic by making several rooms available to the Prime Minister's office. At the beginning of the Second World War, the invading Nazis confiscated the Palace, along with the other Lobkowicz family properties. Returned in 1945, the Palace and all the other properties were seized once again just three years later by the Communist regime.

After more than 40 years of Communist rule (1948–89) and a further 12 years seeking its restitution, the Lobkowicz family are once again the owners of their Palace. In the Spring of 2007, following more than three years of planning, careful restoration and refurbishment, the Palace opened to the public for the first time as a private family museum. The new permanent exhibition there, entitled "The Princely Collections", is drawn from the extensive Lobkowicz Collections. This comprehensive museum installation will not only help revitalize an important cultural site in the heart of Europe, but it will also dramatically enhance the Lobkowicz family's efforts to make these treasures accessible to the Czech people and to a vast international audience.

The Lobkowicz Palace... witness to some of Bohemia's most important historical events

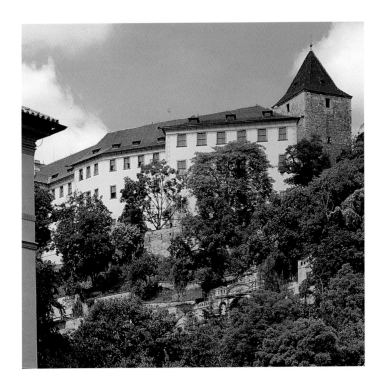

The Lobkowicz Palace

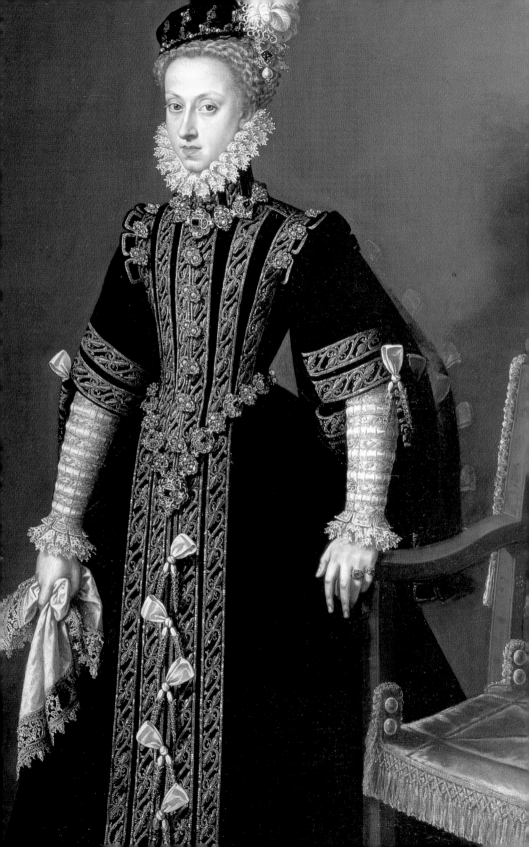

Paintings

O F THE APPROXIMATELY 1,500 paintings in the Collections, it is
the portraits that reveal most about the family's participation in
European political and cultural life, and they figure prominently in both
exhibitions. Very few of the many hundreds of portraits that Dvořák
listed in 1907 are missing today, and the current exhibitions are rich in
portraits dating from the mid-16th century. Among these, the so-called
"Spanish portraits" deserve closest attention.

As previously mentioned, Polyxena, the wife of Zdeněk Vojtěch,
1st Prince Lobkowicz, contributed greatly to the meteoric rise of the
Lobkowicz family fortunes at the turn of the seventeenth century, and
her contribution to the Lobkowicz paintings collection reflected that.
By the time of her death, she had brought to it not only portraits of
the Manrique de Lara y Mendozas and other Spanish relations, but
also portraits of the Pernštejns (her father's family) and the
Rožmberks (the family of her first husband). The sitters in these
paintings included members of those ancient Spanish and Bohemian
families as well as other important personages throughout Europe
who were linked, like the Lobkowiczes themselves, to the Habsburg
courts of Spain and Austria.

The portraits by Philip II's court artist, Alonso Sánchez Coello,
represent the best Spanish portraiture in the collection. Highly stylized,
the sitters appear almost flat, and their extreme formality, severe
countenances and sober, dark clothes are contrasted with dazzling
highlights of jewels and embroidery. Anne, Archduchess of Austria
(painted *c.*1575–80), sister of Rudolf II and niece (not to mention
fourth wife) of Philip II of Spain, and her brother Wenzel, Archduke
of Austria (painted in 1577), are two such subjects. Georges van der
Straeten painted Polyxena's mother, Maria Manrique de Lara (in

*Anne, Archduchess of
Austria* (detail), attributed
to Alonso Sánchez Coello,
oil on canvas, *c.*1575–80

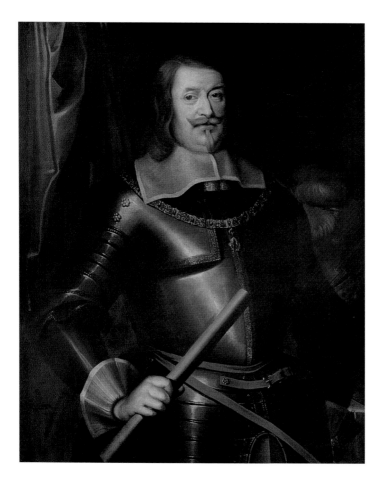

Václav Eusebius,
2nd Prince Lobkowicz,
attributed to Anselmus
Hebbelynck, oil
on canvas, *c.*1650

1575) as well as her sister Elizabeth, Princess Fürstenberg and also Elizabeth, Archduchess of Austria, sister of Rudolf II and later Queen of France. Roland de Mois, court painter to the Dukes of Villahermosa in Zaragoza, painted Polyxena's brother, Jan Pernštejn, as well as her sister Jana and Jana's husband, Fernando de Aragón, 5th Duke of Villahermosa (*c.*1582). Juan Pantoja de la Cruz, Philip III's court artist, painted three daughters of Jana and Fernando de Aragón (in 1593 and 1595) and sent them with inscriptions to their grandmother, Maria Manrique de Lara, in Prague.

By comparison, the Central European portraits in the collection – while lacking, perhaps, some of the polish and sophistication of their Spanish counterparts – have a frankness and intensity which reflected the considerably less restrained courts of Vienna and Prague. The best examples of these are by Jacob Seisenegger, court painter to Emperor Ferdinand I after 1531, who was also engaged by many of those

Vratislav Pernštejn,
follower of Anthonis Mor,
oil on canvas, *c.*1600

Václav Eusebius maintained a close connection to the Infanta Margarita, the exceedingly young wife of Emperor Leopold I

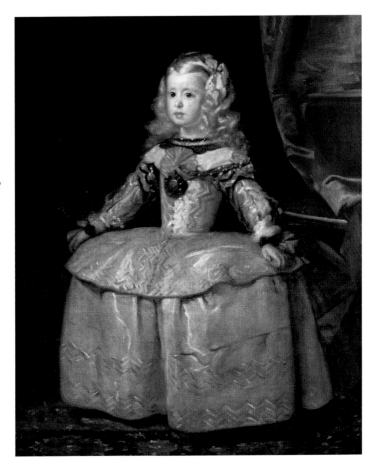

Margarita Teresa, Infanta of Spain, Diego Velázquez (attributed), oil on canvas, c.1655

serving the Emperor, including William Rožmberk, Vratislav Pernštejn and Pernštejn's sister, Marie, Duchess of Teschen. Works by the two court painters to Rudolf II who came to define the Rudolfine style more than any others in the "School of Prague" can also be found in the collection. Bartholomeus Spranger worked for both Maria Manrique de Lara and, later, her son-in-law, Zdeněk Vojtěch, whose portrait was painted shortly before his marriage to Polyxena. And in 1601 Hans von Aachen had completed a refreshingly informal miniature of Kryštof Popel Lobkowicz, a second cousin of Zdeněk Vojtěch and Imperial Chamberlain and High Steward to Rudolf II.

The collection later benefited from Augusta Sophia, Pfalzgräfin zu Sulzbach und bei Rhein, who, upon marrying Václav Eusebius, 2nd Prince Lobkowicz (1609–77), brought to Roudnice portraits from the houses of Pfalz-Sulzbach and Sachsen-Lauenberg. Václav Eusebius maintained a close connection to the Infanta Margarita, the

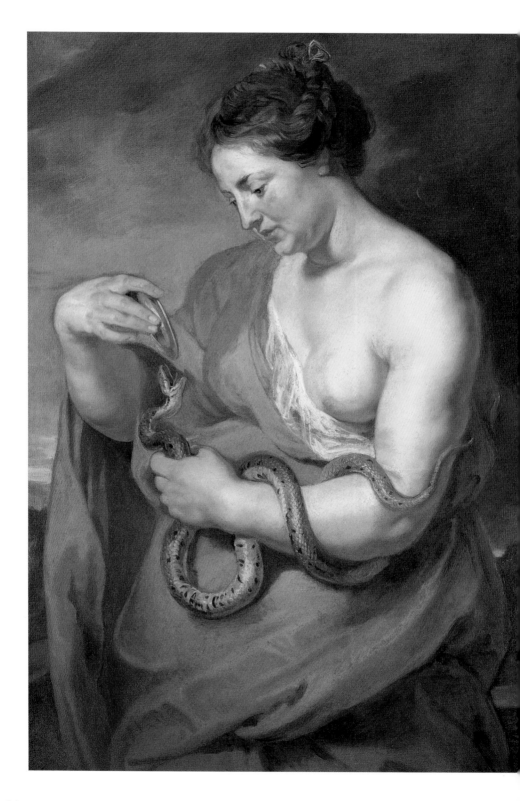

exceedingly young wife and niece of Emperor Leopold I (who was elected Holy Roman Emperor in 1658). The second longest reigning Habsburg Emperor, it was during Leopold's rule that the 2nd Prince Lobkowicz was President of the Imperial Privy Council. Indeed, it was at this time that the collection presumably gained its portrait of the Infanta, attributed to Velázquez and painted in 1655–56, before she married her uncle at the age of nine.

Václav Eusebius's son, Ferdinand August, 3rd Prince Lobkowicz (1655–1715), was the first true connoisseur of paintings in the family. Organizing the collection systematically, he also sought out and began to acquire paintings beyond the realm of portraiture. Paolo Veronese's *David with the Head of Goliath* and Peter Paul Rubens' *Hygieia and the Sacred Serpent* (*c*.1614) are but two of the many Baroque paintings he bought, soon joined by works of lesser-known Italian artists including Francesco del Cairo, Sassoferrato and Antonio

Hygieia and the Sacred Serpent, Peter Paul Rubens, oil on panel, *c*.1614

Madonna at Prayer, Sassoferrato, oil on canvas, *c*.1660

Ferdinand August, 3rd Prince Lobkowicz, was the first true connoisseur of paintings in the family

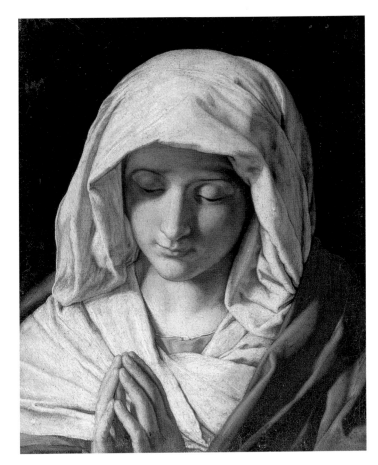

Zanchi. Perhaps it is no coincidence that Ferdinand August's first two wives brought significant paintings collections of their own to Roudnice as dowry.

The first of these women, Claudia Franziska von Nassau-Hadamar, brought portraits by Honthorst, portraits from the various branches of the house of Nassau, as well as a remarkable series of amateur portraits painted by her mother, Ernestine, born Princess von Nassau-Siegen. Maria Anna von Baden, Ferdinand August's second wife, brought many Northern paintings from the collection of her father, Wilhelm, Margrave von Baden-Hochberg. Among these were Lucas Cranach the Elder's *Virgin and Child with Saints Barbara and Catherine of Alexandria* (c.1520), Cranach the Younger's *Christ and the Adulteress* and other works by Georg Pencz, Frans Francken II and Frans Luyckx.

Virgin and Child with Saints Barbara and Catherine of Alexandria, Lucas Cranach the Elder, oil on panel, c.1520

It is likely that many other of the most interesting Dutch, Flemish and German paintings at Nelahozeves Castle entered the collection around the same time, as Ferdinand August seems to have been intent on assembling a cabinet of less obvious, but more refined choices. These include Pieter Brueghel the Younger's *Village in Winter* and Jan Brueghel the Elder's *Saint Martin dividing his Cloak* (1611).

The most important of the Lobkowiczes' Northern pictures is Pieter Brueghel the Elder's *Haymaking*. Painted in 1565 to hang in the dining room of the Antwerp merchant Niclaes Jongelinck, this picture was originally part of a series of six panels, each presumed to represent two months of the year – in this case June and July. In 1594 all six panels were given by the city of Antwerp to Archduke Ernst, Governor of the Netherlands. It is believed that the whole series was selected by Rudolph II at the division of his younger brother's estate in 1595. By 1659 only five panels are listed in the Vienna inventory of the Archduke Leopold Wilhelm (1614–62). It is not known if by that date *Haymaking* had already left the Imperial Collections, nor is it known when the Lobkowicz family acquired it, though it is first recorded as in their possession in 1870. (Three other panels hang in the Kunsthistorisches

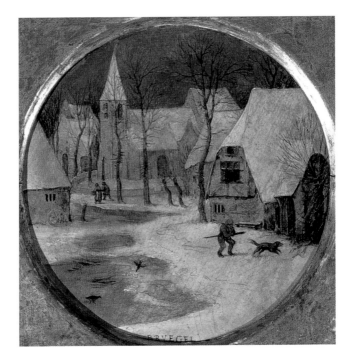

Village in Winter, Pieter
Brueghel the Younger,
oil on panel, *c.*1600

Haymaking, Pieter Brueghel
the Elder, oil on panel, 1565.
Originally part of a series of
six panels, each presumed
to represent two months of
the year, in this case, June
and July.

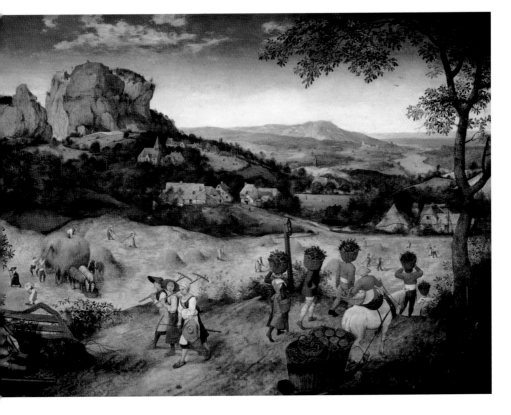

Museum in Vienna and one in New York's Metropolitan Museum; the location of the last panel remains unknown.)

In the eighteenth century, under Philip Hyacinth, 4th Prince Lobkowicz (1680–1734), and his grandson Joseph František Maximilian, 7th Prince Lobkowicz (1772–1816), most of the family patronage centered around music and theater. Canaletto's *The River Thames on Lord Mayor's Day* and *The River Thames looking towards Westminster from Lambeth*, however, both painted just after Canaletto's arrival in London in 1746, are spectacular exceptions, and certainly the greatest eighteenth-century paintings in the collection. Like his nephew Bellotto – whose *Lobkowicz Palace, Vienna*, painted during his visit to the city in 1759–60 is as jewel-like as these London views are vast – Canaletto focused with equal interest on the grand and the low, from the Lord Mayor's barge to the gardeners toiling away in the grounds of Lambeth Palace. Rigorous in their clarity and detail, utterly modern and unidealized, these northern, urban subjects, captured through the eyes of Italians, represent a neat inversion of the classically-oriented *vedute* normally brought home from the Grand Tour.

With these acquisitions, however, any exceptional art patronage ended. Throughout the nineteenth century, both the Lobkowicz family and the paintings they commissioned were characterized by a kind of Biedermeier contentment – introverted, domestic and personal. Attention was turned towards their estates in Bohemia and the family activities conducted there, illustrated by a series of over 50 paintings and watercolors of the Lobkowicz properties in Bohemia, executed between 1840 and 1845 by the German painter Carl Robert Croll.

No less than the formal court portraits assembled by Polyxena and Zdeněk Vojtěch in the seventeenth century, these Croll commissions reveal the politics of family pride. In effect, each Croll constitutes a kind of landscape "portrait," recording the extent and richness of the Lobkowicz property featured. And while they often depict charming, informal scenes intended for the domestic enjoyment conducive to a more relaxed era – and in turn inspired dozens of Biedermeier-period watercolors painted by family members themselves and later bound in albums – a more public purpose of the Crolls remains unmistakable; once again paint and brush were marshalled to enhance the family's image.

The finest 18th-century painting in the collection, executed soon after the artist's arrival in London in 1746: *London: The Thames looking towards Westminster from Lambeth*, Antonio Canaletto, oil on canvas, 1746–47

Dining Room at Jezeři Castle (detail), Carl Robert Croll, watercolor, c.1840–45

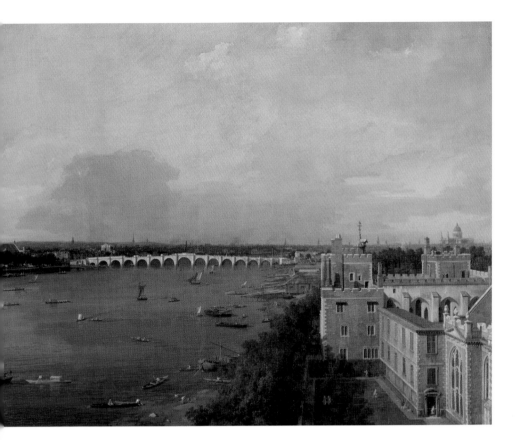

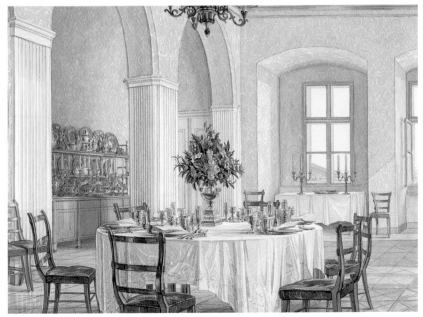

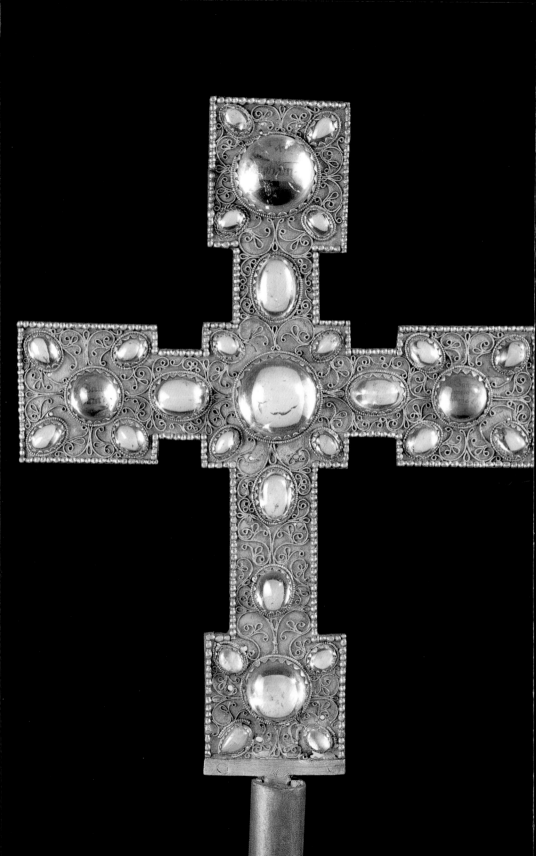

Decorative Arts

Romanesque silver-gilt and
rock crystal cross, Lower
Rhine/North German, c.1125

Group of three pieces from
the Delft service, tin-glazed
earthenware, Delft, c.1685

WHILE NEVER AS WELL KNOWN as the paintings, books or music associated with the Lobkowiczes, the decorative arts objects they amassed – both those intended for ceremonial purposes and those for daily household use – now form a significant part of the Collections.

During the Nazi occupation and the Communist regime that followed, the family's private castle chapels were desecrated and their contents dispersed. The most important objects survived, however, and they have once again been united. Among these are a twelfth-century Romanesque cross of silver gilt and rock crystal, and the so-called "Jezeří" reliquary in the form of a bust of a female saint (St. Ursula?) dated c.1340. The altar celebrating the marriage of Bohuslav Hasištejnský z Lobkowicz to Anna z Fictum, completed in 1574, is particularly remarkable for its decorative workmanship. The interior, richly embroidered with pearls, semi-precious stones and gold and silver thread also includes three-dimensional figures that were inspired by the school of Cranach. Another important marriage commemoration piece is the 1603 house altar presented to Polyxena (1566–1642) and Zdeněk Vojtěch (1568–1628), 1st Prince Lobkowicz, by Rudolf II. The Emperor had brought to Prague artists from the Grand Ducal workshops in Florence who specialized in *commessi in pietra dura* (the decorative use of inlaid hardstones) and for this commission he directed them to use that technique to incorporate elements of the Lobkowicz and Pernštejn coats of arms into the altar's base.

Easily attracting the attention of invading armies and other thieves, and often melted

down to provide currency, objects in precious metals were always the first to disappear from a household. While the collection still contains some excellent examples of seventeenth-century Baroque metalwork – almost all of them from the great German gold and silverworking centers of Nuremberg and Augsburg – it is the missing pieces that are perhaps more noteworthy. Preserved in the archives is an illustrated inventory cataloguing the Lobkowicz collection of late Gothic and Renaissance table and display silver. Recorded in superb detail between 1650 and 1660, it provides precise evidence of a family *Silberkammer* of at least 427 pieces, one of the richest and most sophisticated of its time. Though none remain in the collection, identical examples of certain pieces, such as an elaborate automaton of the mythological Diana riding a stag, can be seen in New York's Metropolitan Museum and Berlin's Kunstgewerbemuseum.

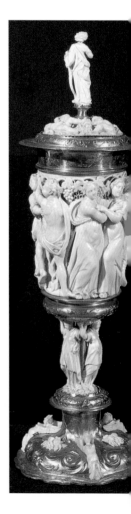

German silver-gilt mounted carved ivory cup and cover, Augsburg, 1653–55

Late Renaissance and early Baroque Italian ceramics feature prominently in the collection, dating from a time when Central Europeans were switching from metal (pewter in particular) to glazed earthenware, for hygienic as well as aesthetic reasons. Such commissions also served to remind contemporaries in Bohemia that one was commissioning the same objects as any cultivated Italian patrician. Vratislav Pernštejn, Chancellor of the Czech Kingdom, acquired several pieces of majolica from his trip to Italy in 1551, some of the earliest Italian ceramics brought to Bohemia. He later commissioned another service decorated with both his coat of arms and that of his wife, Maria Manrique de Lara, to commemorate his receiving the Order of the Golden Fleece from Philip II in 1555 – the first time a Czech had been thus honored.

The Italian travels of both Vratislav Pernštejn and William Rožmberk must also have influenced the direction of their own ceramics workshops in Bohemia: the Pernštejns' in Pardubice and at the Pernštejn Palace in Prague; the Rožmberks' in their towns of Bechyně and Třeboň. One hundred years later, Italian Renaissance designs were still influencing ceramics produced in the Anabaptist communities of Moravia and Slovakia, as many fine pieces in the collection exemplify.

By the late seventeenth century, collecting oriental hard-paste porcelain had become an obsession for many Europeans. The Dutch factories at Delft, with their tin-glazed earthenware, were early imitators of this luxury item. Around 1685, the earliest and certainly the largest Delft service still surviving was produced at the De Metalen

Pot pottery (*c.*1670–91) under the supervision of the master Lambertus Cleffius (died 1691) for Wenzel Ferdinand, Count Lobkowicz of Bílina (1656–97). Count Lobkowicz commissioned this service (150 pieces are extant) when he was Imperial Envoy to the Netherlands. The service entered the Collections through the marriage of his only surviving child and heiress, Countess Eleonora Carolina Lobkowicz (1685–1720) to her distant cousin Philip Hyacinth, 4th Prince Lobkowicz (1680–1734).

The Chinese conceits of this service's typical blue and white glaze, with its floral and bird decoration, stand in striking contrast to Count Lobkowicz's European monogram – a swirling WL, surmounted by his coronet – which adorns almost every piece. Perhaps one of the very first dinner services to be made entirely of earthenware in Northern Europe, many of the shapes were borrowed from more traditional silver pieces. The use of earthenware became increasingly common among the affluent classes at this time as it was less costly than gold and silver and, above all, more hygienic.

For centuries, the secret to producing "true" porcelain was as coveted as the arcanum for transmuting lead into gold. In the first decade of the eighteenth century, however, the Chinese monopoly on this craft was finally broken when the Saxon factory at Meissen, just

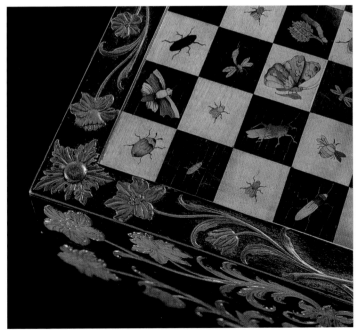

Game board (detail), Eger, fruitwood, last quarter 17th century

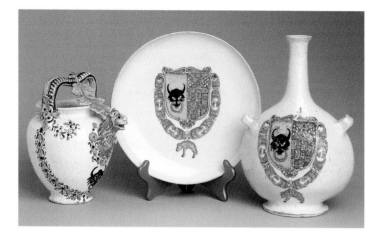

Commissioned by Vratislav Pernštejn to commemorate his being awarded the Order of the Golden Fleece in 1555: **Group of three pieces from the Pernštejn dinner service**, *c*.1556

outside Dresden, began producing the first authentic hard-paste porcelain in Europe. Soon after, its output would be enhanced with brilliant glazes, sculpting and gilded decoration. The factory's proximity to the Lobkowiczes' main properties is reflected in the prevalence of Meissen pieces among the collection's eighteenth and nineteenth-century porcelain, with examples ranging from early *chinoiserie* to later, more traditional European designs.

Some of the most refined woodwork in the collection comes from the Eger craftsmen who worked in Western Bohemia throughout the seventeenth century. With their panels of exquisite high-relief carving, often depicting mythical and classical figures, these pieces almost qualify as works of sculpture. The collection also contains several Eger jewelry cabinets, which rank among the finest produced.

The best furniture in the Collections reflects the Central European love of the Baroque, a style which lasted far longer here than in the rest of Europe. Of course, compared with their Italian and French contemporaries, the local craftsmen lacked a certain finesse. They compensated for this, however, with their creativity and originality by using bolder shapes and designs, often with an exaggerated theatricality which carried on well into the eighteenth century in Central Europe. Examples from the seventeenth century include many cabinets, often with inlaid decoration of ivory, *pietra dura*, mother-of-pearl, tortoiseshell and various types (or contrasting grains) of wood.

Whether purchased as works of art or as practical necessities, the decorative arts pieces in the Collections were intended for both display as well as for use in the private rooms and more public reception halls of the family's many residences.

The best furniture in the Collections reflects the Central European love of the Baroque

Pietra dura **table top** with panel of birds and still lifes of flowers and fruit (detail), 17th century

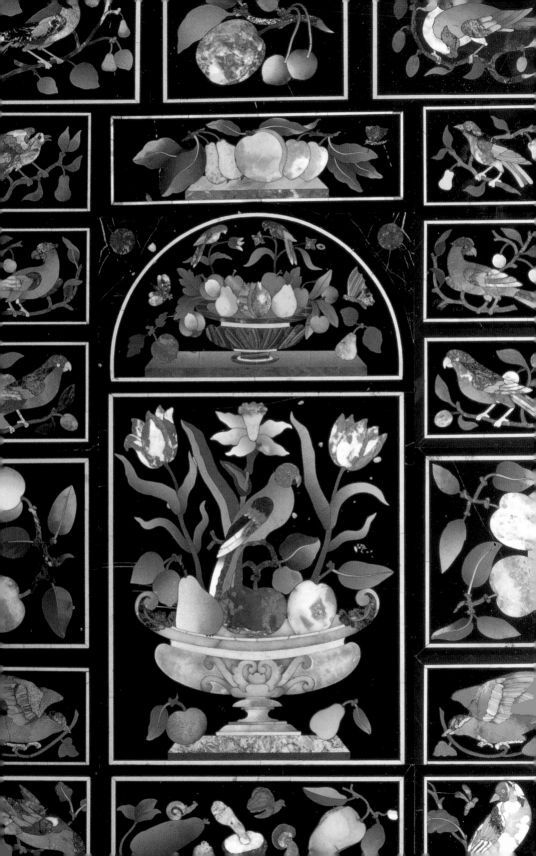

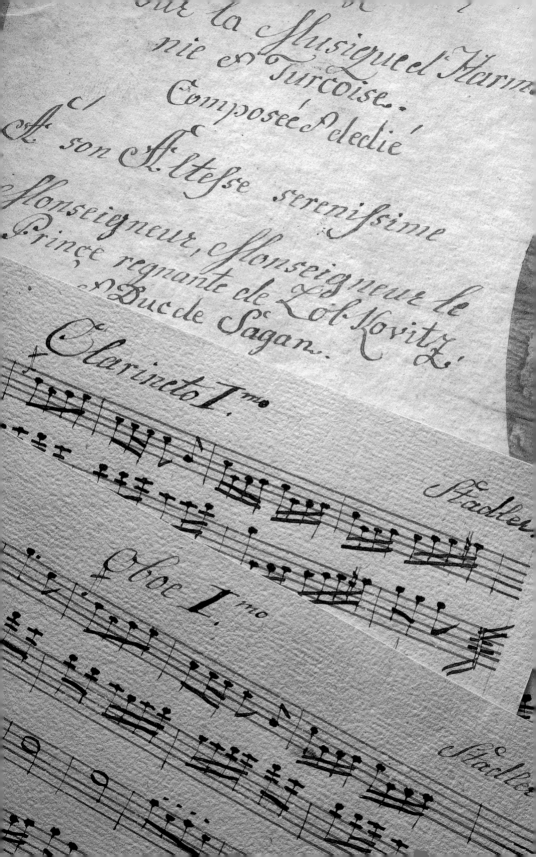

Music

MANY ARISTOCRATIC FAMILIES ACTED as patrons of music, but few on the scale of the Lobkowiczes. Beginning with the wedding of Zdeněk Vojtěch and Polyxena Pernštejn in 1603, the family employed their own musicians and orchestra and became justly famous for its generous support of composers and musicians. Accomplished on the lute, Ferdinand August, 3rd Prince Lobkowicz (1655–1715), expanded on his interest in music by systematically collecting musical scores – a tradition which would last three centuries. Today, the music archives contain more than 4,000 manuscripts and printed scores, all of which were bought by the Lobkowiczes between the end of the seventeenth century and 1870. The oldest manuscripts – late seventeenth- to early eighteenth-century French sheet music for lute, guitar and mandolin by composers like Jacques de St. Luc, Charles Mouton and Jacques de Gallot – are tremendously rare.

Even more distinguished a lutenist – as well as a composer of note – Ferdinand August's son, Philip Hyacinth, 4th Prince Lobkowicz (1680–1734), was in contact with the composers Arcangelo Corelli and Sylvius Leopold Weiss. Weiss was considered one of the finest lutenists of his day and Philip Hyacinth duly appointed him as music teacher to his second wife, Anna Maria Wilhelmina von Althan, to whom the composer dedicated several works. Nor would this be the last such musical association for the Lobkowiczes.

In the mid-eighteenth century, the father of Christoph Willibald Gluck worked as a forester for the Lobkowicz princes at Jezeři Castle. The talents of the young Gluck were soon noted, and he was subsequently employed to play in the Lobkowicz Palace orchestra in Vienna. Later, in 1745, he was with the 6th Prince Lobkowicz,

Undated manuscript of *A March in the Turkish Style* by Joseph Stadler, composed for and dedicated to Ferdinand Philip, 6th Prince Lobkowicz

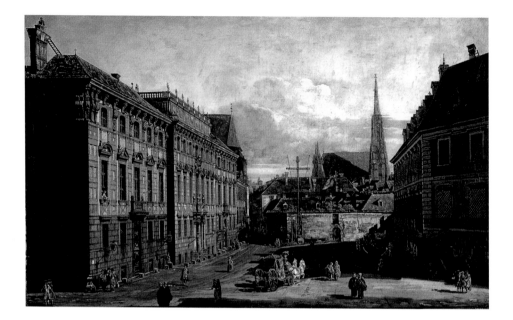

Lobkowicz Palace, Vienna,
Bernardo Bellotto,
oil on canvas, *c.*1760

Ferdinand Philip (1724–84), in England. There, the prince continued to promote him, attending an opera composed by Gluck at the King's Theatre and exposing him to such luminaries in his circle as the Count of St. Germain, a musically-minded eccentric who generally introduced himself as being 400 years old and wrote a treatise on music that was directed to English ladies of taste and dedicated to none other than Ferdinand Philip.

It was also most likely in London that Ferdinand Philip bought his first edition of George Frideric Handel's oratorios, printed in the 1740s by J. Walsh, H. Wright and W. Randall. Among the other acquisitions during his travels were a variety of contemporary operas by composers such as Carl Heinrich Graun, Johann Adolf Hasse and Leonardo Leo.

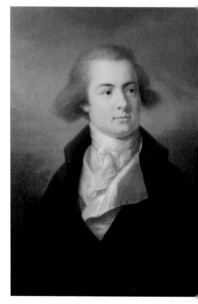

Of all the Lobkowiczes, however, it was Joseph František Maximilian, 7th Prince Lobkowicz (1772–1816), who made the most lasting mark through his musical patronage. His was a fertile period for music composition and, thanks to the prosperity of the family, he was able to provide generous support to orchestras, musicians and composers alike. Talented as a singer, violinist and violoncellist, Joseph František Maximilian had a genuine passion for music. He was also a founding

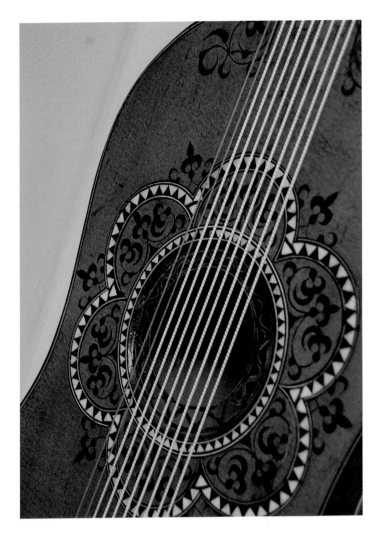

Five-course guitar,
School of Sellas,
second quarter 17th century

Joseph František
Maximilian, 7th Prince
Lobkowicz, August
Friedrich Oelenheinz,
oil on canvas, c.1810.
Of all the Lobkowiczes,
he made the most lasting
mark through his musical
patronage.

member of the Society of the Friends of Music in Vienna, a member
of the Society for the Promotion of Musical Culture in Bohemia
(which begat the Prague Conservatory) and a director of the Court
Theater of Vienna.

Music was constantly played during evenings spent among
aristocrats of the Austro-Hungarian Empire, and at the Lobkowicz
residences in Vienna, Roudnice and Jezeří, concerts were held on a
regular basis – usually by the family orchestra which Ferdinand Philip
had founded, conducted successively by Antonín Vranický, Antonio
Cartellieri and Johann Joseph Rössler. The instruments used by the
orchestra are now part of the music collection, and include, along with
numerous nineteenth-century wind instruments, several sixteenth-

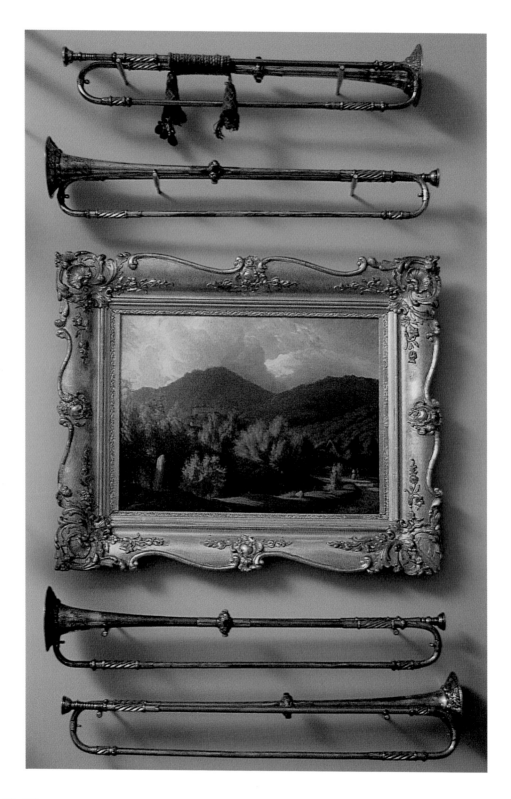

century lutes, a guitar from the seventeenth century, violins of Italian, German and Czech origin (Gasparo da Salò, Grancino, Stainer and Eberle) double basses from Posch and Stainer, trumpets made in 1716 by Michael Leichamschneider in Vienna, a spinet and three pairs of copper and bronze kettledrums.

On some evenings, famous artists were invited to sing, such as Luigi Bassi, one of the most celebrated baritones of his time, who performed in *Don Giovanni* at its Prague premiere of 1787. Bassi went on to spend eight years in the service of the Lobkowiczes. Occasionally, Joseph František Maximilian himself took to the stage, as he did in 1805, singing the part of the Archangel Raphael in the Czech rendition of Haydn's *Creation*. Perhaps this was only right, as Haydn's work had been largely funded by him.

Joseph František Maximilian's most important relationship, however, was the one he shared with Ludwig van Beethoven. The two met early on in one another's life, in 1792, shortly after Beethoven had arrived in Vienna at the behest of Count Waldstein. Joseph František Maximilian was just 20 years old and Beethoven was 22.

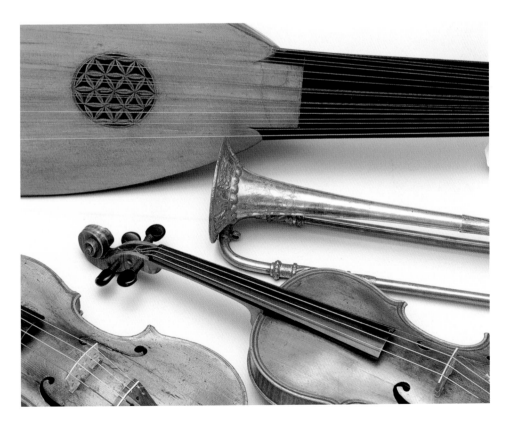

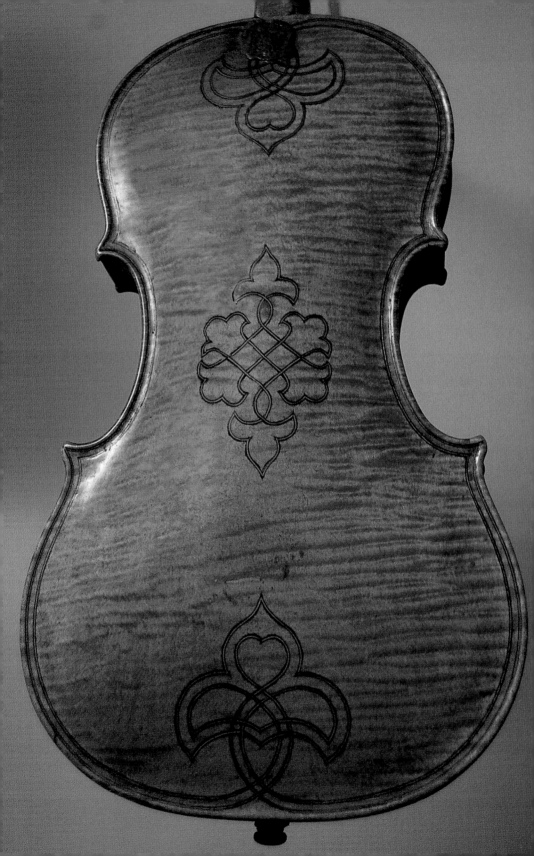

Thereafter, the young prince followed the development of the composer closely, enabling him to stay in Vienna despite his previous commitments to the King of Westphalia in Kassel, and along with Archduke Rudolf and Count Kinsky, Joseph František Maximilian guaranteed Beethoven an annuity that would allow him to work without financial worry.

As he did with his loyal supporters, Beethoven repaid Joseph František Maximilian by dedicating a number of pieces to him – in this case, the six String Quartets opus 18, the Triple Concerto, the Harp Quartet opus 74 and the lieder cycle *An die ferne Geliebte*, as well as the 3rd (*Eroica*), 5th and 6th Symphonies. Originally dedicated to Napoleon, the 3rd Symphony was performed for the first time, privately, at Jezeří Castle in 1804, one year before the first public performance in Vienna. After the financial crash of 1811, which sent the fortunes of many aristocratic families tumbling, payments of Beethoven's pension had to be suspended, somewhat upsetting the harmony between composer and patron. At this point, the impatient Beethoven took to using the affectionate nickname "Fitzliputzli" for Joseph František Maximilian – an apparent double-edged play on the name of the mighty Aztec god Huitzlipochtli. The payments soon resumed, however, and continued to be paid even after the death of Joseph František Maximilian in 1816, until Beethoven's own death in 1827.

Among the Beethoven treasures in the archives are early manuscripts of his works, including copies of the 4th and 5th Symphonies and the Opus 18 String Quartets containing the composer's original corrections as used at the first public performances of those pieces. Joseph František Maximilian also bought a variety of other scores for the archives. Between 1798 and 1810 Wenzel Sukowaty, principal music copyist for Vienna's court theatres, delivered countless operas and other musical manuscripts to him. Furthermore, family account books document intense activity by other copyists, among whom at the beginning of the nineteenth century were the Viennese Matthias Retzer, the Beethoven copyist Wenzel Schlemmer and Ignaz Raab.

Violin, attributed to Gasparo Bertolotti, called da Salò, Brescia, last quarter 16th century

Lute by Marx Unverdorben, 16th century, adapted to the Baroque form by Thomas Edlinger (1662–1729), Prague

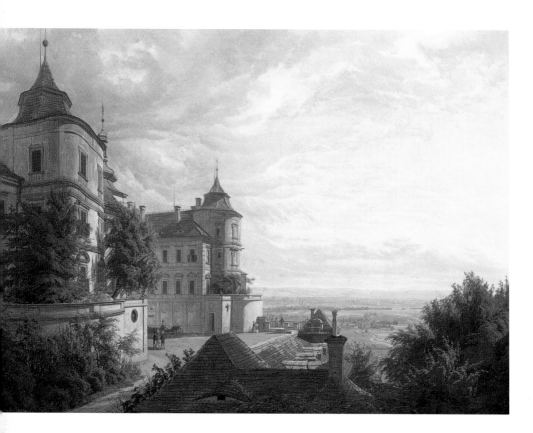

One of Joseph František Maximilian's finest contributions was to add to the collection of Handel scores started by his father. Among these is a manuscript of the *Messiah*, revised and reorchestrated by Wolfgang Amadeus Mozart in a torrent of annotations. Indeed, a number of Mozart's works can also be found in the music archives, including *Cosi fan tutte*, which was played at Roudnice in 1798, *Don Giovanni*, played many times at both Jezeří and Roudnice, *La clemenza di Tito* and *Le nozze di Figaro*. This same predilection for operas explains the inclusion of many contemporary opera composers like Ferdinando Paer, Joseph Weigl, Johannes Simon Mayer, Peter Winter, Antonio Cartellieri and Johann Rössler. Capping off this extraordinary series of sheet music acquisitions was the purchase, in 1800, of Antonín Vranicky's entire collection, followed, 10 years later, by that of his brother, Pavel.

Today, the Lobkowicz music archives constitute a major resource for musicians and musicologists, not only for the vast number of unpublished or out-of-print scores they contain, but also for the unique glimpses into the creative process which they offer.

Landscape with Jezeří Castle, Carl Robert Croll, oil on canvas, 1843

A manuscript of Handel's *Messiah* annotated by Wolfgang Amadeus Mozart for his own 1789 reorchestration of the oratorio

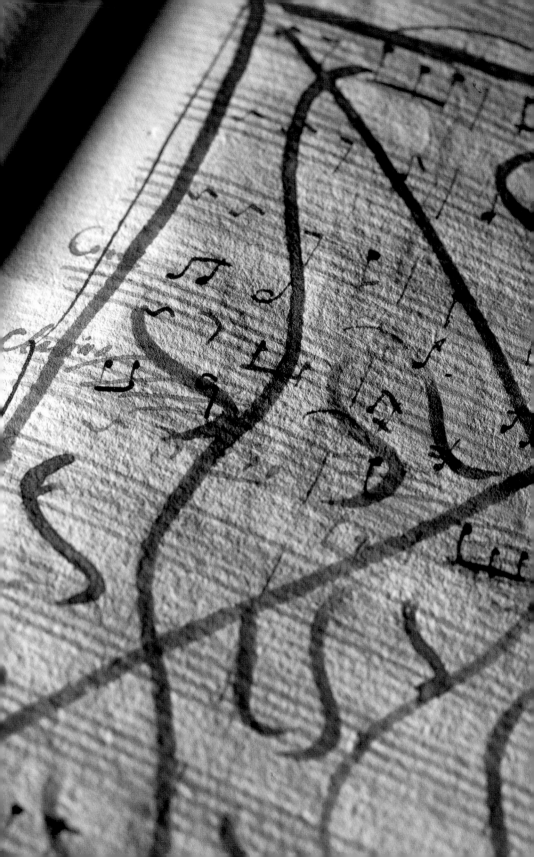

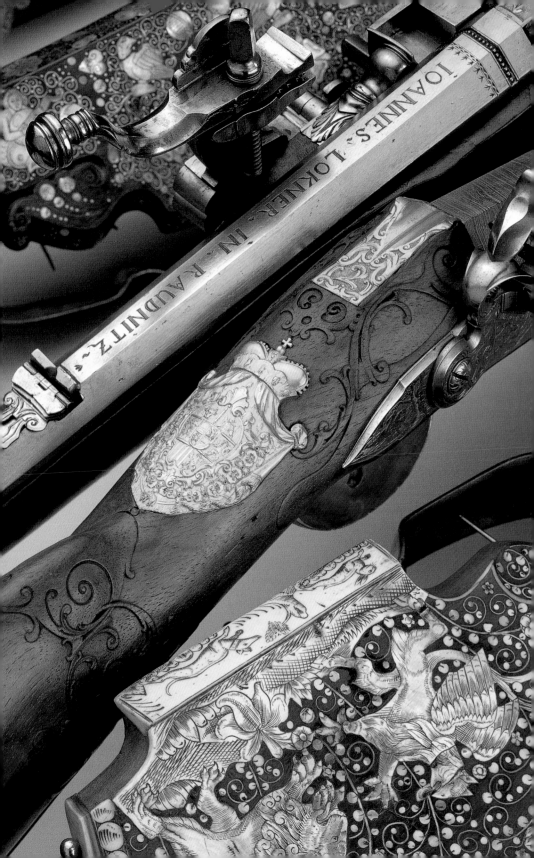

Hunting and Shooting

From the late Renaissance until the land reforms of the twentieth century, the great estates of Bohemia and Moravia, with their vast forests and parkland, provided some of the best hunting in Europe. Taking their cue from the customs of the Imperial court – such as the stag hunts which Rudolf II organized in the forested ravines protecting the Prague Castle – the landed elite made hunting a central pursuit. Not that this was an idle passion; hunting was very often the best way a young prince or nobleman could gain the kind of training he needed for warfare. The chase was a privilege of those who not only owned large amounts of land but who could also afford to dedicate them to sport. The additional expense of employing falconers, gamekeepers and foresters, as well as maintaining stables, kennels and gun rooms only added to the exclusivity of hunting – and to its allure.

It is to these hunting landowners that we owe a huge debt of gratitude; they were great conservationists and environmentalists before the words were in use, because without a diverse habitat, the animals that they hunted would not have survived. They planted millions of hardwood trees at great expense, which provided shelter for deer, wild boar and other game. Without a habitat there would be no game to pursue and much of the European wooded landscape, with stately mature trees now hundreds of years old, is a direct result of hunting. Since the decline of the hunting aristocracy, the incentive to protect and plant trees has been lost. During the more leisure-oriented period of the nineteenth century, however, country estates crept into the realm of the theatrical, displaying an almost obsessive fascination with the bagging of animals. Konopiště, Archduke Franz Ferdinand d'Este's hunting castle in Central Bohemia, was perhaps

Hunting rifles, Silesia, Bohemia, Austria, 17th–18th century

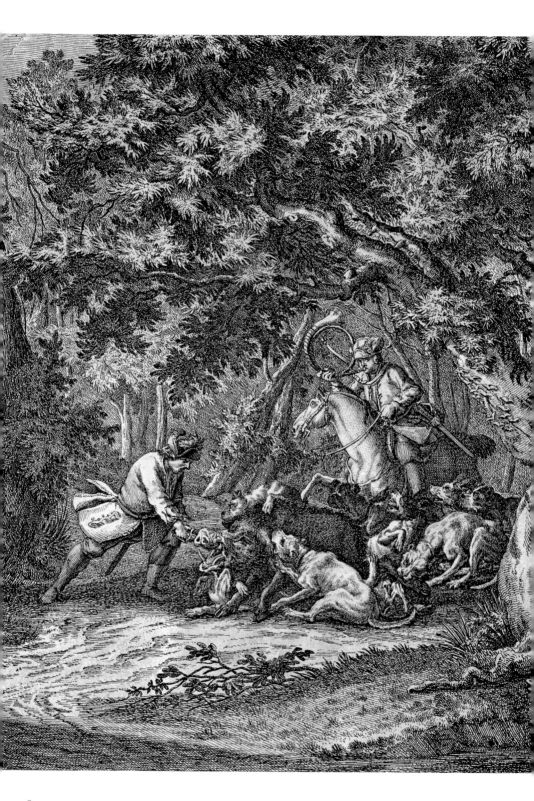

the most exaggerated result of this, with room after room of pheasant tails hung as densely as wallpaper and antler racks mounted by the thousand.

The Lobkowiczes were no exception to this trend. From Jezeří, their cherished Baroque castle built high in the forests of the Erzgebirge mountains that form the border between North Bohemia and Saxony, to Vysoký Chlumec, their late Gothic fortress looking out over the hills and fields of Central Bohemia, all of the major Lobkowicz properties served as venues for the hunt. While Joseph František Maximilian may have preferred to hunt alone by moonlight, heavy socializing was more often the rule. Watercolors and photo albums record long days of shooting that were followed by evenings of amateur theatricals with family members and neighbors. Also recorded are more official events, like the 1804 hunting visit of Prince Louis Ferdinand of Prussia, which included opera and concerts at Roudnice Castle. On occasions such as the visit of King Frederick August of Saxony in 1905 for shooting at Roudnice, gunpowder and game counts were not the only topics of conversation; political and business deals were often negotiated, marriages suggested and rivalries extended.

Bearing witness to these hunting parties and their participants are hundreds of mounted trophies in the Lobkowicz Collections that date from the eighteenth through to the early twentieth centuries. Painted on many of them is the name of the man or woman shooting, as well as the date and place of the hunt. These trophies were hung prominently in hallway entrances, not only to remind visitors of the host's own prowess with a rifle but also to serve as a precise record of where the hunt had taken place and who had attended. They were also hung in respect for and admiration of the quarry that had provided fresh food to feed large house parties and the servants.

The social aspects of the hunt are also reflected in the many paintings and graphics by local artists in the collection, among them pictures of favorite horses, dogs and trophies, which generally referred to the people to whom they belonged. It is perhaps the engravings of Johann Elias Ridinger that reveal most about hunting in Central Europe. Together with his two sons, Martin Elias and Johann Jakub, he depicted all forms of the sport for much of the eighteenth century. Over 1,700 different copperplate engravings were published by the Ridingers, commemorating a series of extraordinary animals and the personalities who hunted them. Hung by the hundred throughout the Lobkowicz castles, these prints both inspired

Die Schweins Hatz (detail), Johann Elias Ridinger, copperplate engraving, Augsburg, 1792

the hunting enthusiast while serving as reminders of similar personal triumphs and experiences.

In the Ridingers, as on the trophy-hung walls, the subject of great fascination was the odd or the grotesque. From the late Renaissance through to the Baroque, the most coveted prizes were not necessarily the largest but those marked by some unusual feature: two hares sharing a single head, deer hooves that curled over themselves, antlers that grew in clusters like fungi or fused the scalp to form bizarre helmets. Prized equally by hunters and collectors, these objects often found their way into curiosity cabinets. Later, in the nineteenth and early twentieth centuries, safaris and expeditions to more exotic regions became fashionable, and the Lobkowiczes even supplemented their own collections with stuffed crocodiles.

The most potent totems of the hunt, however, are the firearms themselves. After being in storage for many years, some of the finest are now on display in two Armory Rooms at the Lobkowicz Palace at Prague Castle, while others from the collection are on view at Nelahozeves Castle. The majority of these rifles and pistols were produced locally for the family between 1650 and 1750 – the high point of Central European firearm production. The seventeenth-century Prague workshops of Adam Brand, Paul Ignatius Poser, the Neireiter family and Leopold Becher produced many of these firearms, as did

First Armory Room, Lobkowicz Palace

Roudnice craftsmen such as Johannes Lackner and Adel Friedrich during the mid-eighteenth century. They are a lasting tribute to the patronage of the Lobkowicz family, who provided the gunmakers with large orders for guns throughout the centuries.

A very special feature of the private collection is a group of identical flintlock rifles produced for the Lobkowicz Militia in the eighteenth century, probably one of the largest of its kind in existence. They are displayed in trophies and fans in the Armory Rooms in the Lobkowicz Palace. Additional weapons came from Silesia, while the most elaborate eighteenth-century rifles and pistols (some in the Turkish manner) with mother-of-pearl inlay were produced in Vienna by the renowned gunmakers Felix Meyer, Marcus Selma and Johann Fruwirth. The gunmakers who signed their names on the finished

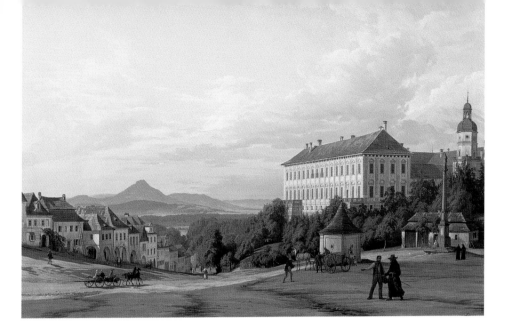

Roudnice Castle from the Town Square, Carl Robert Croll, oil on canvas, 1840

weapons employed a variety of highly skilled craftsmen including lock makers, barrel makers and gun stockers. Goldsmiths and silversmiths specializing in inlay were employed to decorate guns, rifles, crossbows and powder flasks of the finest quality. It is perhaps the renowned skill of the steel chisellers and engravers who, working from pattern books, have left behind a legacy of decorated actions of unsurpassed quality. Like the clockmakers of the period, only when the final product was finished to the desired standard would the 'maker' add his signature.

The earliest actions in the collection are to be found on the long-barreled military muskets from Roudnice, dating from the mid-sixteenth century. They are known as matchlock actions and are followed, in chronological order, by the wheel-lock, snaphaunce lock, flintlock and finally the percussion lock, which was invented by a Scottish clergyman, the Rev. Alexander Forsyth, around 1810. Whatever the type of action, they are found on pistols (generally smooth bore), carbines (short-barreled rifles used on horseback or for shooting park deer from a tree), shotguns (smooth bore for bird shooting, firing a measured amount of small lead shot) or rifles made with heavy rifled barrels firing a single lead ball at larger game – deer, ibex or wild boar.

These firearms represent the marriage between power and art more clearly than any other part of the Collections, for what were conceived as instruments of war and conquest have become artworks to be admired. Today, long since the last of these guns were fired, they stand as objects of beauty – vestiges of the Lobkowicz family's storied past.

What were conceived as instruments of war and conquest have become artworks to be admired

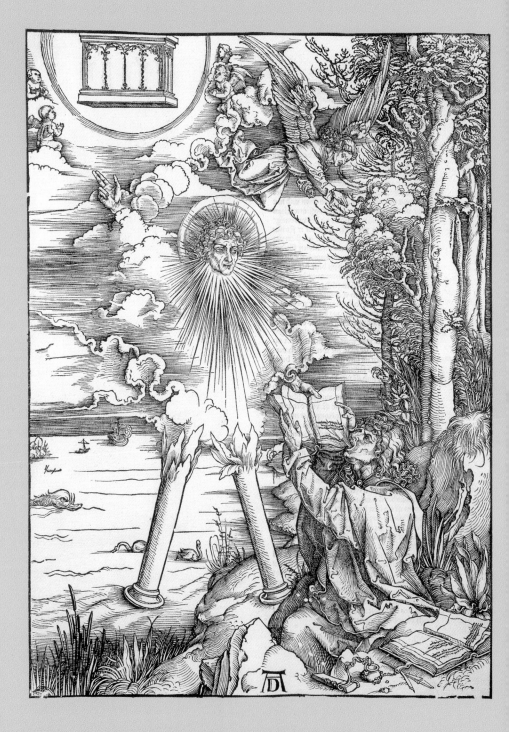

Library

AMONG THE MANY TREASURES of what must be considered one of the great noble libraries of Europe is an extremely rare copy of the 48-line Bible, printed on vellum in 1462 by Fust and Schöffer in Mainz, with chapter initials in blue and red. Perhaps even more dazzling is a copy of *St. John's Account of the Apocalypse* printed in Nuremberg in 1498 by Anton Koberger, illustrated with 15 vivid and fantastical woodcuts by Albrecht Dürer. These are just two of the books from the Lobkowicz library that were dispersed for over 50 years. Not all of its treasures were recovered but today the library has been reassembled into something close to its original state, and is once again housed on Lobkowicz property. A monument to the care of generations and their passion for books, the collection contains almost 65,000 volumes in Greek, Latin, Hebrew, Italian, Spanish, German, French and Czech, including 679 manuscripts (114 dating from the Middle Ages) and 730 incunabula, a large proportion of which are first editions of works in history, geography, medicine, natural science, architecture, literature, theology and law.

Over the six centuries of its existence, the library grew through sophisticated and systematic acquisitions, not only of individual volumes but entire libraries – whether those of immediate and distant relations or those of Bohemian aristocrats whose fortunes had declined. Much of this is documented in the family's vast archives, which recorded new acquisitions, transfers and reorganizations, various approaches to cataloguing, and even the costs of bookbinding and repairs. The history of the library is also told by the books themselves – through their bookplates, both printed and handwritten, as well as through annotations made in the margins, which remain as intriguing evidence of how the books were

St. John Devouring
the Book, a woodcut
from *St. John's Account
of the Apocalypse*
by Albrecht Dürer, printed
1498 by Anton Koberger.
Only five known complete
copies of this book are
preserved in the world.

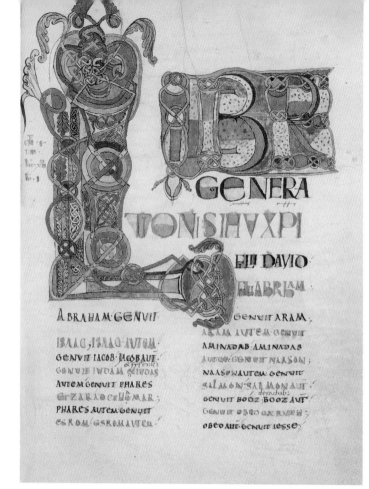

The most ancient codex in the library, the **Gospel Book** (*Evangelarium*), 10th century, from the library of Bohuslav Hasištejnský. Depicted initial "L" for "L"IBER (beginning of *Matheus*).

interpreted – and sometimes misinterpreted – by their readers.

The origins of the library date back to the fourteenth century. The core of the collection, however, was assembled a century later by Bohuslav Hasištejnský z Lobkowicz (1461–1510), the most distinguished representative of Latin Humanism in Bohemia. With the help of his friends and agents, Bohuslav collected almost 700 volumes without regard for cost, creating the largest humanist library in the Holy Roman Empire, famous even in his own time. Of this collection, more than 420 printed books and over 30 manuscripts survive today. Bohuslav's library was, above all, that of a humanist, dominated by classical philosophy and literature, much of it in Latin, with 29 printed books and 16 manuscripts in Greek. The rarest Greek manuscript is Plato's *Dialogues and other Treatises*, written and illuminated on vellum in Italy in the late fourteenth century, and the only manuscript still preserved in the Czech Republic that contains Plato's Dialogues. In addition, an uncommonly large number of books printed in Italy

demonstrate the close relations Bohuslav maintained with his peers on the peninsula – relations which occasionally exposed him to criticism by other Czech humanists. One of the most rare religious volumes Bohuslav acquired is the *Evangelarium*, an illuminated manuscript from the tenth century. It is written on parchment in beautiful Carolingian minuscule, the initials decorated with vegetative and figural motifs, as well as certain early-Christian elements, and the canon tables are written in ornamental columns set within architectural designs.

Some of the most significant additions to the Lobkowicz library date back to the beginning of the seventeenth century, with the political ascent of Zdeněk Vojtěch, 1st Prince Lobkowicz (1568–1628). His advantageous marriage to Polyxena Pernštejn in 1603 enriched the library immeasurably, as Polyxena brought with her

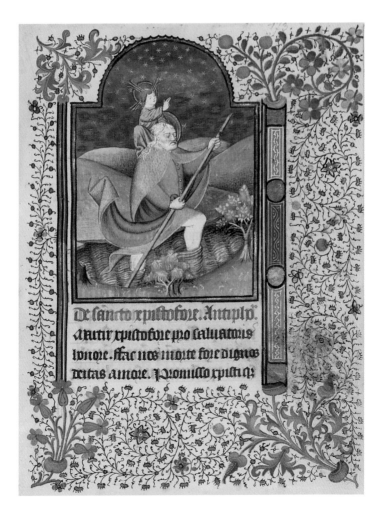

This illuminated manuscript came to the library in the 19th century from the collection of Marie Leopoldina Liechtenstein, born Princess Esterházy, mother-in-law of Ferdinand Joseph, 8th Prince Lobkowicz. **Book of Hours**, Latin prayer book on vellum created around 1440 in Angers, France.

about 60 Spanish volumes bequeathed by her mother, Maria Manrique de Lara, as well as some rare books from her father's family, the Pernštejns, and that of her first husband, William Rožmberk. In addition to religious literature, these inheritances included a considerable number of classical translations from the Latin (Seneca, Cicero, Titus Livius), geographical, travel and historical books (accounts of Africa, China and the Holy Land), works on war and military themes, and prints illustrating important monuments.

Impressed on the vellum covers of all of the books from Maria Manrique de Lara is a gilded *supralibros*, or cover design, of a tower accompanied by the motto, *Inconcussa manet* ("It withstands the storm"). This motto would come to have great meaning for Polyxena, who, with her husband, Zdeněk Vojtěch, stood on the front lines of the Counter-Reformation in Bohemia, and temporarily lost the family properties – including the library – following the revolt of the Protestant Estates in 1618. After the Battle of White Mountain in 1620, however, the library benefited enormously from a re-Catholicized political landscape. Many Protestant nobles lost their properties and possessions, leaving Zdeněk Vojtěch and Polyxena in the position to buy up libraries such as that of Ladislav Zejdlic ze Šenfeldu and the doctor Matyáš Borbonius z Borbenheimu (1569–1629) personal physician to Emperor Rudolf II and to his brother and successor, Emperor Matthias. Borbenheim's books, consisting of 118 volumes mostly on medicine, alchemy and chemistry, are all decorated with his own elaborate, gilded *supralibros* and inside contain extensive personal annotations written in red ink.

Václav Eusebius, 2nd Prince Lobkowicz (1609–77), also contributed greatly to the growth of the library, acquiring hundreds of books a year from the most important book centers – Frankfurt and Augsburg. In addition, he transferred the library from the Lobkowicz Palace in Prague to Roudnice Castle, shortly after it had been reconstructed to serve as the family seat. There, he reorganized the collection, establishing both a comprehensive cataloguing system and a strict set of rules to protect the books and prevent their dispersal.

The library further prospered under Václav Eusebius's son, Ferdinand August, 3rd Prince Lobkowicz (1655–1715). Roudnice at this time was a significant cultural center, a meeting place for a variety of personages from across Europe. Reflecting this vitality, the library was rich in classical literature, history and the most important

Over the six centuries of its existence, the library grew through sophisticated and systematic acquisitions

contemporary treatises on law, theology and medicine. As a result of the marriage of Eleonora Carolina, last of the Bílina branch of the Lobkowiczes, to Philip Hyacinth, 4th Prince Lobkowicz (1680–1734), that library was later incorporated into the one at Roudnice. The books from Jezeří Castle, which the 6th Prince Lobkowicz had recently acquired, also came to join those at Roudnice after 1752.

Under Ferdinand Philip, 6th Prince Lobkowicz (1724–84), the Silesian wars menaced the family properties, including Roudnice, which was occupied by the army and used as a military hospital. The library, walled in, remained inaccessible from 1741 until 1777. Before departing Roudnice for Jezeří, however, the 17-year-old prince spirited away a number of books for safekeeping, along with other valuables. Among these were manuscripts and incunabula from Bohuslav's library and certain books from the Borbenheim and Frankenstein libraries. Later, during his long sojourns in Germany, France and England, Ferdinand Philip met many of the most interesting figures of his day and bought ten times as many books as his father had. He was chiefly interested in classical literature, theater, poetry and music, but also the sciences, from mathematics and astronomy (T. Brahe, J. B. Riccioli) to chemistry and the natural sciences, botany in particular (L. Fuchs, P. A. Mattioli, L. Thurneisser zum Thurn) which, to satisfy his peculiar, neo-Rudolfine tastes, he complemented with books on alchemy and Rosicrucianism (M. Maier, A. Libavius, J. R. Glauber, Paracelsus) and all the curiosities of nature.

A Peacock and a Vial, illumination from the late-15th-century manuscript of the famous alchemic treatise *Aurora consurgens* (Rising Aurora). One of the two earliest preserved versions of the *Aurora consurgens* in the world (the other is held in Zürich).

Future generations continued to incorporate into the Roudnice library the book collections of extinct branches of the family, as well as those of other aristocratic families into which they married, like the Liechtensteins, Esterházys, Imhofs, Hochsingens and Stadions. Generally, these were books of literature, art, music and the natural sciences. By the turn of the twentieth century, politics had also become an important topic, and German and Czech newspapers were bought and collected on a regular basis.

In 1941, under the Nazi Protectorate, the Lobkowicz books were confiscated and repeatedly moved, and after 1948 were widely dispersed throughout various Communist state institutions. Today, however, the library is once again united and housed in completely reconstructed quarters at Nelahozeves. It serves as a magnificent example of the ancestral motto, *Inconcussa manet*. It has indeed withstood the storm.

Hoc variare, decus mundi est: hæc
Artificis.

Omne quod Æternus per verbum cona
Autoris nomen celebret, laudesque re

z summi

auctor.

4

Archetypa studiaque patrie Georgii Hoefnageliis (detail from part 4, folio 1), Jacob Hoefnagel (after Joris Hoefnagel), Frankfurt am Main, 1592

History of Nelahozeves Castle

THE MONUMENTAL NELAHOZEVES, one of Bohemia's finest Renaissance castles, is located in a small village of the same name, approximately 15 miles north of Prague on the Vltava (Moldau) river, known also for being the birthplace of the great Czech composer, Antonín Dvořák.

Nelahozeves is an example of the *castello fortezza*, a style deemed very modern around 1550. Florian Griesbeck von Griesbach (1504–88) most likely employed the royal master builder Bonifaz Wolmut to construct his Italianate Mannerist-style castle. A highly educated Tyrolean aristocrat, Florian Griesbeck served as private secretary and close adviser to Emperor Ferdinand I. Florian amassed great wealth and in 1544 bought land at Nelahozeves.

His ambitious new residence, which took 60 years to build, was planned as a two-story building with four wings and four corner pavilions resembling spur-shaped bastions. The facade's *sgraffito* decorations (a technique where a top layer of color is scratched to reveal a color beneath) on the north wing, some of which have been restored, show scenes from ancient mythology and the Old Testament. Of the Castle interiors, the most noteworthy are the south facing Arcade Hall on the first floor and a magnificent room with a well-preserved interior dating back to 1564. Known as the Knight's Hall, the room is dominated by a huge Renaissance fireplace and it is decorated with frescoes of larger-than-life figures. The room features a lunette vault that has a central panel with nine sections, separated by stucco fruit festoons and other stucco reliefs depicting delicate elongated figures. The theme depicted on the ceiling is Titus Livius' description of the five examples of Roman virtues.

When Florian Griesbeck died in 1588, his son Blasius inherited

the Castle and construction continued until the beginning of the seventeenth century. In 1623, the family's financial difficulties forced Florian's granddaughter to sell the encumbered estate to Princess Polyxena Lobkowicz, whose family have owned the Castle ever since. During the Thirty Years' War (1618–48) the Castle was ransacked several times. Following the war, Polyxena's son, Prince Václav Eusebius Lobkowicz, High Chancellor of the Czech Kingdom, carried out reconstruction work on the building and used it for the administration of his properties. The Castle's original and authentic appearance is due to the fact that only limited structural changes were made to it over the centuries.

During the second half of the 1960s, the exterior of the Castle was restored, and during the late 1970s and 1980s, the Czech Regional Gallery used Nelahozeves Castle to house modern "socialist" art, as well as some of the Lobkowicz Collections. The Castle was returned to the Lobkowicz family in 1993 and a temporary exhibition was immediately opened. From 1997–2007, a permanent exhibition ("Six Centuries of Patronage") featured some of the most significant private art in Europe. When, in 2007, elements of the Collections were transferred to the Lobkowicz Palace in Prague Castle for public display, Nelahozeves was re-installed with historical period rooms portraying the lifestyle of the Lobkowicz family through the centuries, in a permanent exhibition entitled "Private Spaces: A Noble Family at Home."

Nelahozeves from the River Vltava, Carl Robert Croll, oil on canvas, 1841

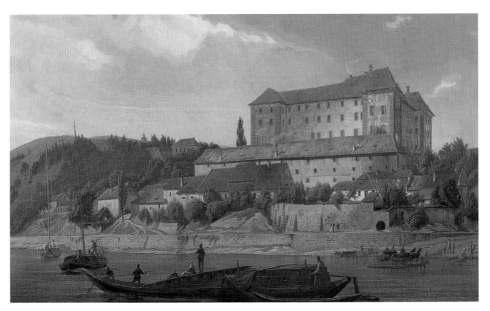

Practical Information

The Lobkowicz Collections are on display at the Lobkowicz Palace in Prague and at Nelahozeves Castle, approximately 35 km north of Prague. For a plan of the Lobkowicz Palace and travel directions to both venues, please see inside back cover.

Lobkowicz Palace

Lobkowicz Palace
Prague Castle
Jiřská 3
119 00 Prague 1
Czech Republic
info@lobkowicz.cz
www.lobkowicz.cz

Opening Hours
The Lobkowicz Palace is open daily 10am–6pm, all year round.

The Permanent Exhibition – "The Princely Collections"
The Exhibition is open from 10am
Audio tours are available, free of charge, in Czech, English, French, German, Italian, Japanese, Russian and Spanish.
Guided tours for individuals and groups, personally conducted by Lobkowicz Palace guides, are available by reservation only.
For reservations: tel. (+420) 233 312 925.
Last audio tour begins at 5.30pm
Last guided tour begins at 5pm

Daily Concerts
Classical music concerts are held every day in the beautifully restored Concert Hall, with its magnificent seventeenth-century painted stucco ceilings. Works by famous Czech and international composers – such as Mozart, Vivaldi, Dvořák and Beethoven – are performed by an accomplished trio consisting of flute, violin and piano.
Performances take place daily at 1pm, and last approximately 1 hour

Café & Restaurant
The Lobkowicz Palace Café & Restaurant is situated on the ground floor of the Palace and offers a wide selection of hot and cold meals, snacks and beverages, including traditional Czech dishes and Lobkowicz wine and beer. With seating for over 230 people, the setting includes an indoor restaurant, balconied terraces with panoramic views of Prague and two Renaissance courtyard spaces.
Open daily 10am–6pm

Museum Shop
The Lobkowicz Palace Museum Shop, detailed with original family objects and mementos, presents a rich assortment of reproductions and adaptations from the magnificent Lobkowicz Collections. Many of the items for sale have been developed exclusively for the Museum, with unique items based on Czech or Central European motifs, as well as selected souvenirs of Prague and Prague Castle. Award-winning Lobkowicz wines are also offered for sale.
All sales from the museum shop support the restoration and conservation of the Collections, as well as educational programs.
Open daily 10am–6pm

Venue Hire and Event Catering
All rooms on the first floor, including the Imperial Hall, Concert Hall and the Balcony Room (with a terrace featuring panoramic views of Prague) may be rented for social events, weddings, conferences, seminars or private concerts. Lobkowicz Events Management and its multilingual staff will be pleased to arrange all necessary details, including accompanying programs or entertainment, as well as catering services. For information: tel. (+420) 728 309 816.

NELAHOZEVES CASTLE

Nelahozeves Castle
277 51 Nelahozeves
Czech Republic
nelahozeves@lobkowicz.cz
www.lobkowicz.cz

OPENING HOURS
Nelahozeves Castle is open Tue-Sun 9am–5pm, from 1 April–31 October.

THE PERMANENT EXHIBITION –
"PRIVATE SPACES: A NOBLE FAMILY AT HOME"
The Exhibition is open from 9am
Guided tours for individuals and groups are available. Groups must arrive 10 minutes prior to the planned start of the tour (not applicable for tours starting at 9am) to present their reservation confirmation to the Museum Shop staff.
For group reservations:
tel. (+420) 315 709 121 (Tuesday-Sunday) or (+420) 315 709 154/111 (Monday);
e-mail: nelahozeves@lobkowicz.cz
Last guided tour begins at 4pm
(no tours noon–1pm)
Foreign-language guided tours are available in Czech, English, French, German, Italian and Russian.
The maximum number of visitors per group is 20.

RESTAURANT
The well-reviewed Castle Restaurant, with a seating capacity of 55, is conveniently located on the first floor of the Southeast Bastion, and overlooks the garden. The dining room is decorated with furniture, artwork and family porcelain from the extensive Lobkowicz Collections. The Castle chefs prepare both traditional Czech and international cuisine.

Award-winning Roudnice Lobkowicz wines, and beer from the 600-year-old Lobkowicz brewery are served exclusively.
Open Tue-Sun 10am–5pm

MUSEUM SHOP
The Castle Museum Shop, detailed with original family objects and mementos, presents a rich assortment of reproductions and adaptations from the magnificent Lobkowicz Collections. Many of the items for sale have been developed exclusively for the Museum, with unique items based on Czech or Central European motifs, as well as selected souvenirs of Prague and Prague Castle. Award-winning Lobkowicz wines and beers are also offered for sale. All sales from the museum shop support the restoration and conservation of the Collections, as well as educational programs.
Open Tue-Sun 9am–5pm

VENUE HIRE AND EVENT CATERING
The first-floor salons, the Castle courtyard and the cellars of Nelahozeves Castle may be rented for social and cultural events (receptions, concerts, weddings, wine-tastings, seminars and workshops) as well as business presentations and conferences. Lobkowicz Events Management and its multilingual staff will be pleased to arrange all necessary details, including accompanying programs or entertainment, as well as catering services.

ANTONÍN DVOŘÁK BIRTHPLACE
A small museum and monument dedicated to the most celebrated Czech composer is situated immediately adjacent to the Castle.

Viewing the Lobkowicz Collections

Below is a list of the works featured in this guide, showing the venues where they are located.

Lobkowicz Palace

Nelahozeves Castle